Many thanks to C. Deschamps, B. Freeman, J. Lyons, and J. Mohns!

This publication is made possible
in part with public funds
from the New York State Council on the Arts
and a Visual Artists Fellowship grant
from the National Endowment for the Arts.

First printing 1000 copies, January 1988
The Visual Studies Workshop
31 Prince Street
Rochester, New York 14607

ISBN: 0-89822-051-3
L.C. Catalog No. 87-51190

THE RETURN
OF
THE SLAPSTICK
PAPYRUS

F. DESCHAMPS

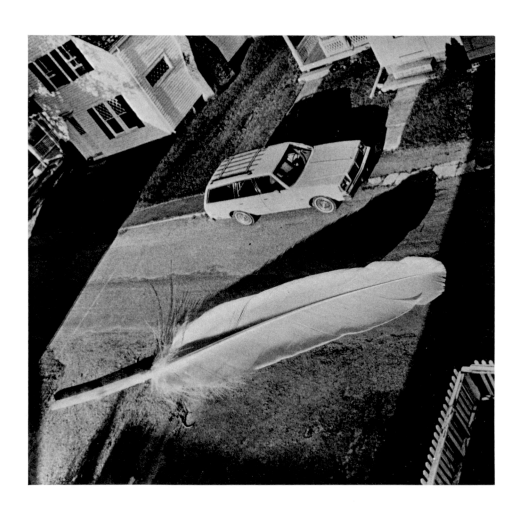

Contents

Introduction vii
The Doctor's Bird 1
The Hall of Beauty 15
The Terror Begins 27
Worlds Apart 37
Eat the Rich 43
Pension Ægyptus 53
A Postcard Message 63
The Three Stones 81
The Butterfly Collection 95
Inside the Image Factory 105
Postscript 123

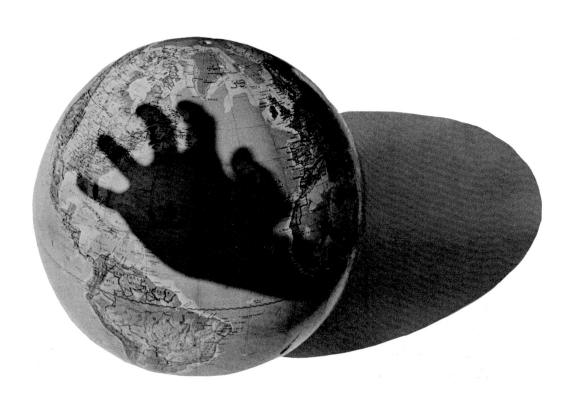

This story begins in 1998. A few notes are in order for readers unfamiliar with the life of that time. The world was divided into rich and poor; each group had its own culture. Rulers used images to control the world. In the notorious Sigma Parlors the wealthy would enjoy and live illegal images. Gangs associated with the Parlors were rumored to be responsible for the Eat the Rich Campaign. Rogue, the protagonist of this tale, is a typical male of the period.

LARGE FEATHER
TICKLES ISLAND

Ibis Island, Me. (UPI) Neighbors of Mr. Robert "Bobby" Wookum found a large feather today at dawn in this quiet island community of 1000. Mr. Wookum could not be reached for comment. His mother, in a telephone inteview, would only reveal that "Bobby has always been a good son." The mysterious feather was taken to the fire station for closer examination. Experts who were rushed to the scene suspect that this feather belongs to a very large gull. Frank Arbuckle, head law enforcement officer, is trying to reassure anxious residents that the situation is under control.

not sold,
another
to. make
m Klink,
olumbia
uthority.
n of. the

yout pro-
lies have
e in the
reports.
ducting
e costs
ral Of-

of this
milies
ll make
r. Klink

ne, re-
rough
yor had
ys she
v'' are
sident
sister
four

"It's

h

The Doctor's Bird

I t's a warm fall day in Chicago with kids still cramming the lakefront beaches. I'm out of work and hitting the bottle pretty hard. I get a call from a Doctor Francisco who says he is Director of the Institute of Obscure Knowledge. Of course I'm supposed to know what that is, and of course I don't. I'm just a private eye, pretty good on the street or in a bar, but not much on obscure knowledge. My name is Rogue, Rogue Savage.

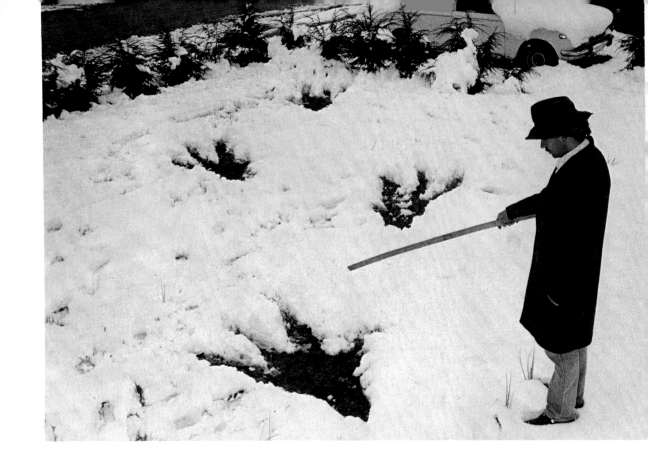

I'm investigating a large bird that keeps leaving traces. That's not a normal assignment in my line of work, but it pays the bills. Doctor Francisco, AKA Doc, is in his late fifties. He always wears a dark coat and a hat. He talks in that precise, clipped way that makes him sound like a nazi in a war film. But he makes silly jokes all the time.

We make cardboard replicas of what the feet must look like. I get the feeling he's just playing, sort of making fun of me. Frankly, I can see we're getting nowhere fast.

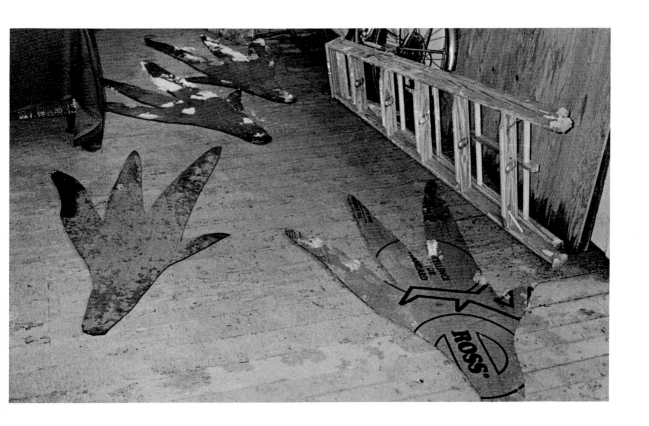

<div align="right">Tuscaloosa, July</div>

Again some of those prints. Police have the area cordoned off, and the papers are calling it the "Big Bird Mystery." They even have names for the bird—Gabrielle, Hot Foot, that kind of thing. It's so muggy I feel like I'm wearing a three-piece suit in a sauna. The Doc still has on his dark coat, and I wonder what he might be concealing. His manner is sneaky. If he weren't my client, I'd peg him for a suspect. I get even more suspicious when he mentions my twin brother Rusty, the Egyptian expert.

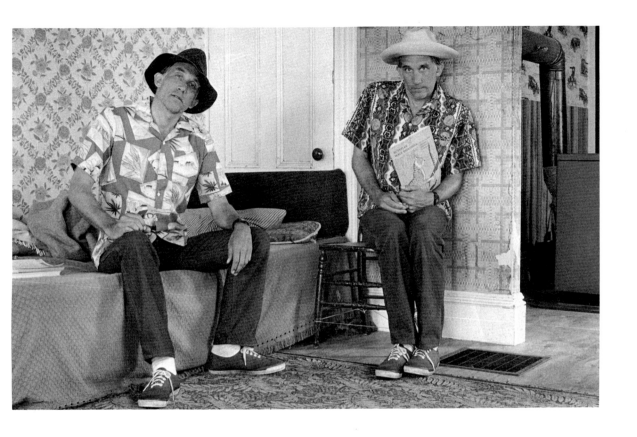

The Doc claims he met Rusty at some conference in Detroit. I'm surprised because Rusty keeps pretty much to himself. He's shy and scholarly, kind of the opposite of me. The Doc wants to know where Rusty is right now. How the hell do I know? And what does all this have to do with our Big Bird Caper? The Doc gets on my nerves with his weird questions and that childish giggle, like every little thing is a joke.

The next day I'm back in the Windy City with red eyes and a heartbeat in my head. I was up drinking all night in a honky-tonk with some broad named Lulu. I couldn't get her to come back with me to the motel. She kept wanting to go to a Sigma Parlor instead.

I walk into my office and Janet, the girl who works for me, comes running up. Now Janet's a pretty girl, and someday I'll talk her into getting a little closer.

"You look like hell and your bird flew the coop," she says. "He's gone. They don't know how it happened. Into a cab and missing at the airport!"

"Let's start this all over, sweetheart. Who's gone?"

"The Doctor! And don't call me sweetheart. Tuscaloosa just called in. Said they couldn't find you. What's more, I got a report from the Agency and I think you'll be surprised."

And boy am I. The Agency report makes no sense. For one thing, it says the Doctor disappeared in Peru three years ago, and here I'd been talking to him just yesterday.

Disappeared

Subject:
"Doctor" Jacob Weinstein Francisco
b. 1941

Occupation: Scholar, gangster

Last known address:
159 Fifth Avenue, N.Y.C.

Last seen: Near Collection Amazonica, Bresil.
Igutos, Peru, at the Cafe Trópica Mi Besil.
July 14, 1995.

History: Born of Jewish/Italian parents, the "Doctor,"
in fact has very little formal education. He has
experimented with Imagery Euphorial states and
transubstantion analysis. His "laboratory" in New
Jersey was implicated in supplying images to
Sigma parlors near Manhattan. His pet seagull,
"Beeky" disappeared from the Fifth Avenue
penthouse shortly after July 14. As director of
the Institute of Obscure Knowledge, he championed
the cause of Logarythm Day as a national holiday.

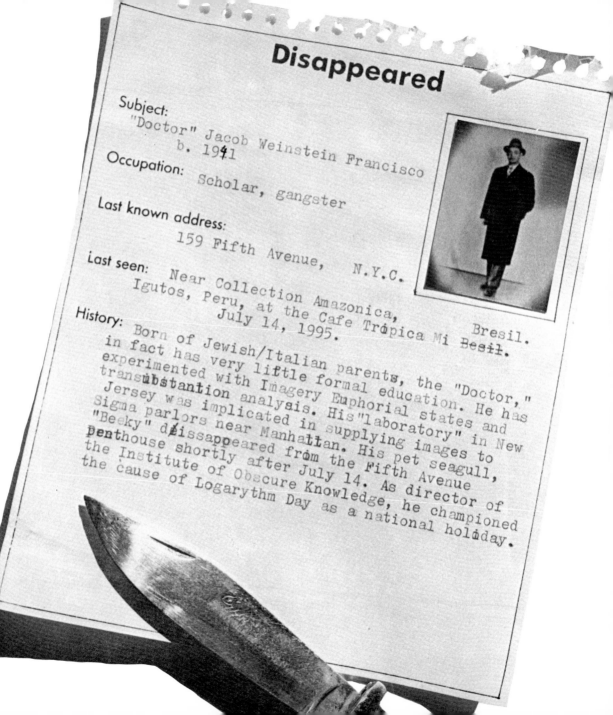

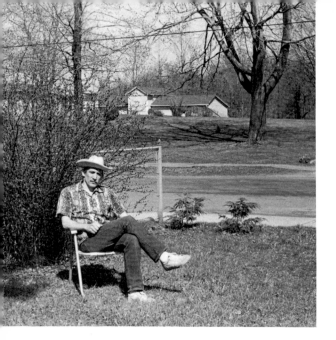

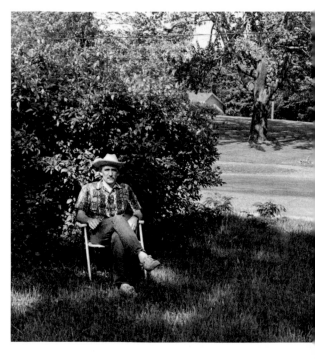

I don't have any real leads. Jack, my buddy at the Agency, is on vacation. I decide to call on Rusty to ask him what he knows about this Doctor Francisco. Now Rusty may have the same genes as me, at least that's what science says, but something must have happened to him along the way. I wouldn't recognize him, except he looks just like me.

He's always been interested in what he calls "Time-Space," as if it were a sort of place he'd visit. I guess in a way it is. Once he stayed seated on a lawn chair for a whole year—doing nothing, just sitting. I couldn't believe it was written up, and he got a lot of attention for it.

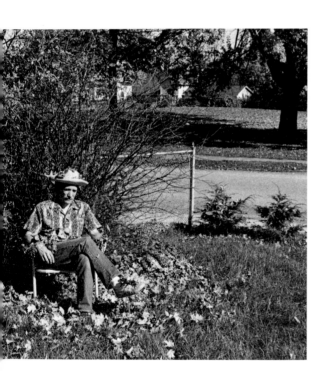

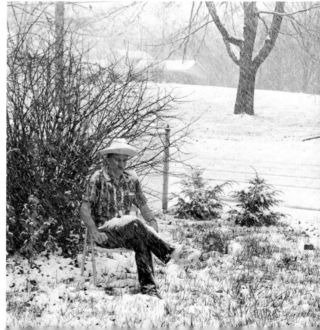

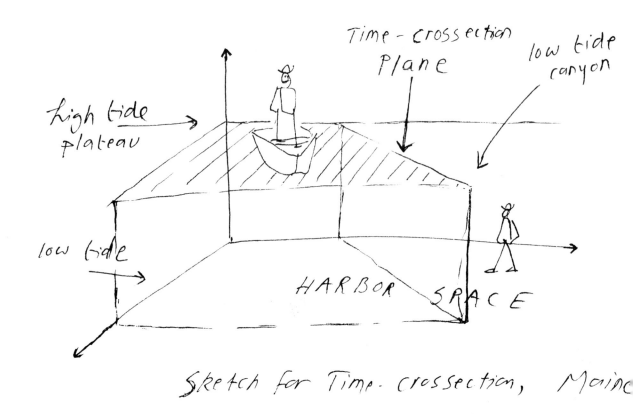

High tide plateau

Time - crossection Plane

low tide canyon

low tide

HARBOR SPACE

Sketch for Time - crossection, Maine

In Maine, Rusty proved he could be in two places and two time zones at the same moment. He called this time-crossections and hyper-relativity something or other. I guess Rusty is pretty brainy, but brains aren't everything. I can never just have a normal conversation with him. If I say something like "I went out with a cute chick last night," he looks at me as if he were examining an interesting scientific phenomenon.

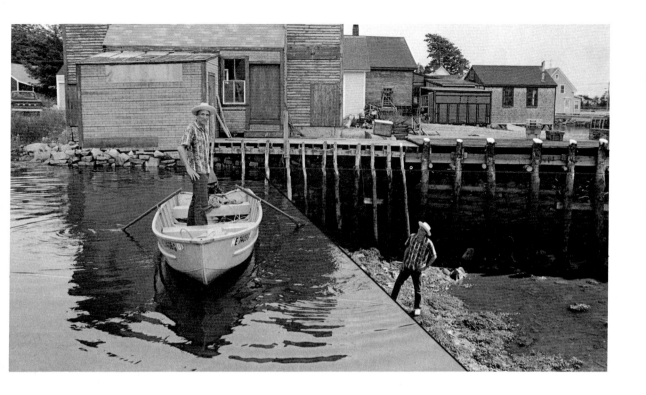

The biggest feather in his cap was the Slapstick Papyrus. He discovered it in the beak of a dead gull in Maine. Carbon-14 tests proved it was the real McCoy—3000 years old and from Ramses IV. Rusty said he was the last Pharoah to rule his kingdom entirely by the use of jokes. To me, the jokes weren't funny, but I guess they tickled the guys back then.

I get to Rusty's house in Roger's Park and find his door nailed shut. A rough sign reads "Gone to Egypt."

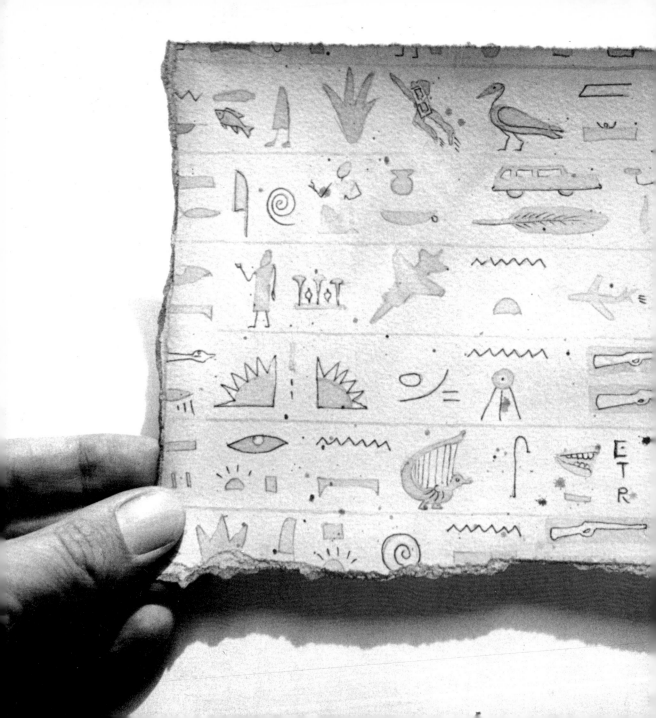

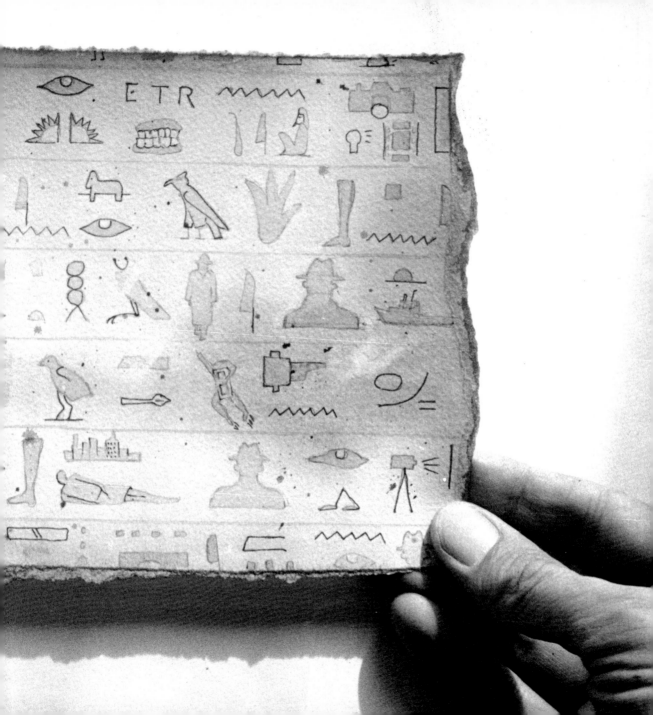

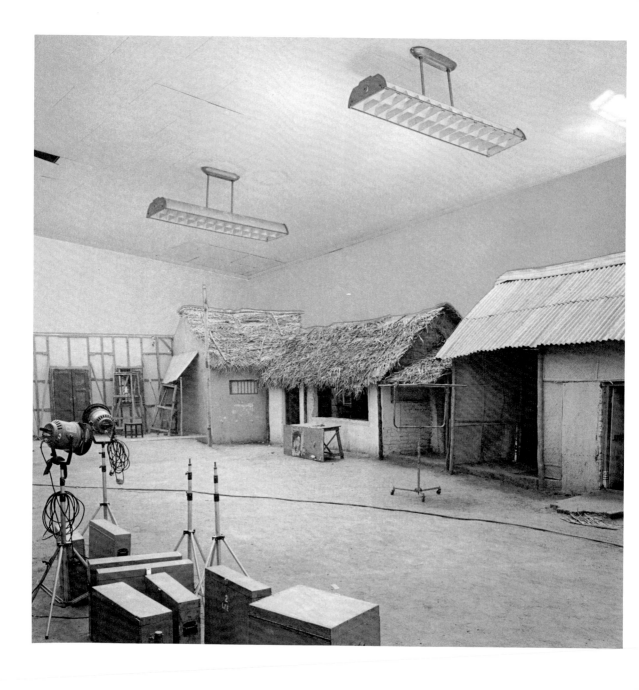

The Hall of Beauty

The boarded-up door and sign are too obvious. I smell a rat. I crawl in through the basement window. Rusty lives in a ramshakle, twenty-room house filled with scientific machines, stacks of papers, boxes, stuffed animals, and a mess of theatrical lights and backdrops. If he weren't my brother, I'd think he was into illegal image scams. I walk through these crazy rooms calling his name. Suddenly I hear a noise behind me. I spin around fast, gun in hand.

There he is with a smirk on his face.

"Can't you read the sign like everybody else, Rogue?"

That's Rusty for you. Always putting me down. I'm used to it now after thirty years, so I just let it go. When I tell him about the disappearance of Doctor Francisco, he's suddenly nervous. He mumbles that the Doctor is an old friend.

16

Then I get it out of him that he had tried a space fusion connecting Doctor Francisco in Paris to an image in Maine. Something had gone wrong. Rusty always uses big words I don't understand, but I get the gist of the story.

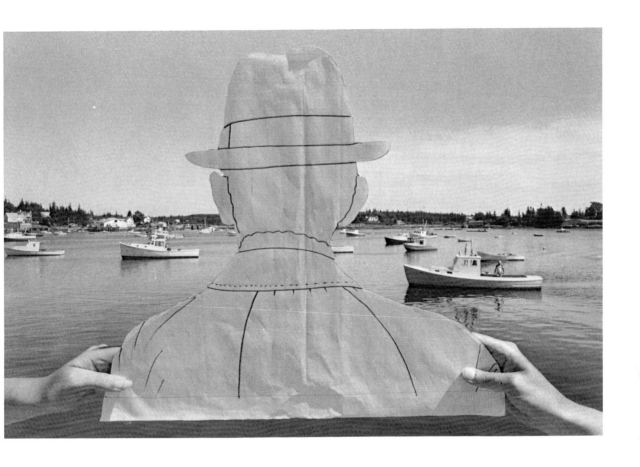

He takes me to the back door. Then he gives me a deep, serious look
and a warm handshake.

"Be careful, Rogue. They play hardball."

Before I can ask "who?" and "what's the game?" he closes the door.

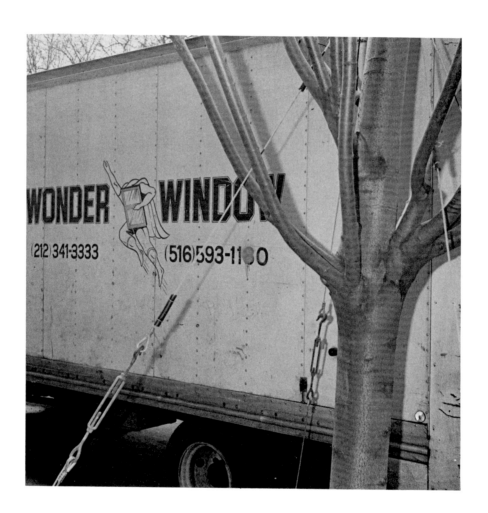

Two weeks later at the office, Janet comes up to me looking real solemn. I think she is going to tell me that she'll finally go out with me. But no.

"Bad news. You'd better sit down, Rogue. Rusty has disappeared."

That doesn't seem so unusual since he's always off somewhere or playing games. But this is different. Seems he went to some Egyptian museum in New York City. A guard, suspicious of this man in a wild pineapple shirt, followed Rusty into the Hall of Beauty. To his amazement the tomb was empty!

New York City, the next day

I don't like New York, and I don't like New Yorkers. A parked truck outside the museum catches my eye. I have this strange feeling I've seen that flying window somewhere. The truck tears out in a hurry. I meet the cops on the scene. They are real thickheads. A private eye can do more in a day than a whole precinct in a week. I contact Jack who's back from vacation. He promises to send me photos of known hieroglyphics thieves. Why they steal the stuff I just don't know. Guess there's a market for it somewhere, maybe in the Far East or behind the Iron Curtain.

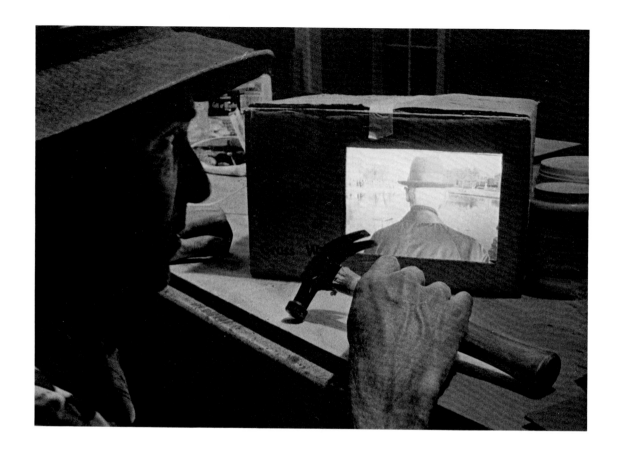

Back in Chicago, I go to Rusty's place. This time he really isn't here. I feel weird remembering that look he gave me the last time. I check out this complicated equipment. Is it from that space fusion experiment? Then I find a yellowing envelope labeled DO NOT OPEN. In it there's a picture of Doctor Francisco as a hole. In some ways, this is the most revealing portrait I've seen of this elusive bird.

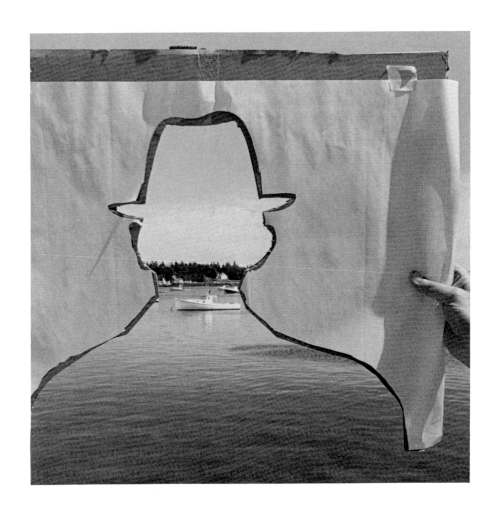

At the office I get the stuff from Jack. I look over the mug shots. All I can say is that like all suspects, they look suspicious to me. There's really only one lead left: Rusty's ex-girlfriend, Katherine.

THE HALL OF BEAUTY.

WONDER WINDOW
(516) 593-11

EGYPT A SEPULCHRE.

them from the Delta, I had traversed for five hundred
the valley of the Upper Nile, and had found it filled with
buried cities: I had seen Thebes a ruin, and now saw the
utter desolation of Noph and On. The whole Nile valley
is a sepulchre, where Egypt is buried, and these are the
monuments that mark the entrance to the tomb. Descend-
ing, I stood again in the solemn presence of the sphinx;
and that huge mysterious head that gazes out, motionless,
fathomless, while the shadows of the past deepened, till the
grave of Egypt was shrouded in eternal night.

The Terror Begins

K atherine Izuto-McGowan is half-Japanese, half-Scottish, and probably all brain. She's some kind of New York Professor, a real one. She's expecting my call. She read about the disappearance in *Archaeology Weekly*, a rag out of New York. Katherine wants to hire me for 500 bills a day plus expenses. Well, I can be bought for less. Anyway, I'm not working for the Doc since he checked out with no forwarding address. I put together a pile of clues from Rusty's place and grab a flight East.

Next day in New York, I meet Katherine at a Greek restaurant for lunch. I see right away she's not much to look at, but she's got class. She has red hair and the only blue Oriental eyes I've ever seen. Like I said, Rusty has strange taste in just about everything. She goes for the octopus and grape leaves. I get a hamburger and fries. I show her the clues. She knows hieroglyphics and says the bird prints and the flying window are from the Slapstick Papyrus. I knew something like that was happening. She claims Rusty had been using too many images lately and thinks he was probably trying to enter the Pyramid of Rebop through The Hall of Beauty by time-splicing.

She says we should go to Wonder Window headquarters in Hackensack. When we get there, it's already on stilts and being moved. Like everything else in this caper, it's disappearing.

As we're driving away, Katherine spots a sign with the sunset from the Papyrus. I guess once you get into these hieroglyphics, you see them everywhere. So here I am on a case with two disappearances, a 3000-year-old joke book that isn't funny, and clues popping up all around. And what does Katherine talk about? She explains Plato's analogy of the cave, how the reality we see is the copy of an ideal, like a shadow cast on a screen from inside a deep cave. She says we live among the shadows of ideals. She sure is a real Professor.

We get lost in New Jersey and wind up stopping for some take out. Katherine eats a huge sandwich. I like a woman with an appetite. As I'm wiping ketchup off the dash, I hear a rumbling overhead, then the sound of a car honking in the sky. Before I know it, an antique cadillac has crashed into the ground, missing us by only a few feet. Katherine grabs my hand, and I calm her down—though I'm pretty badly shaken myself.

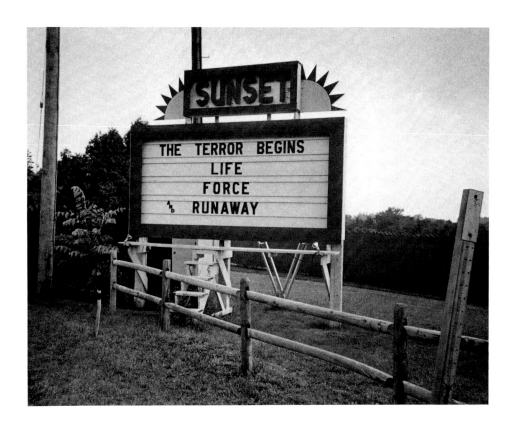

We're in real danger now. I peel out before the law comes, and we head back to the City. I can't believe it when Katherine goes on again about that Plato and language as a system of ideals—not to be misused in the expression of emotions. She sure talks a mean streak. Then she shows me these three smooth stones Rusty gave her the last time they were together. He said they'd come in handy someday.

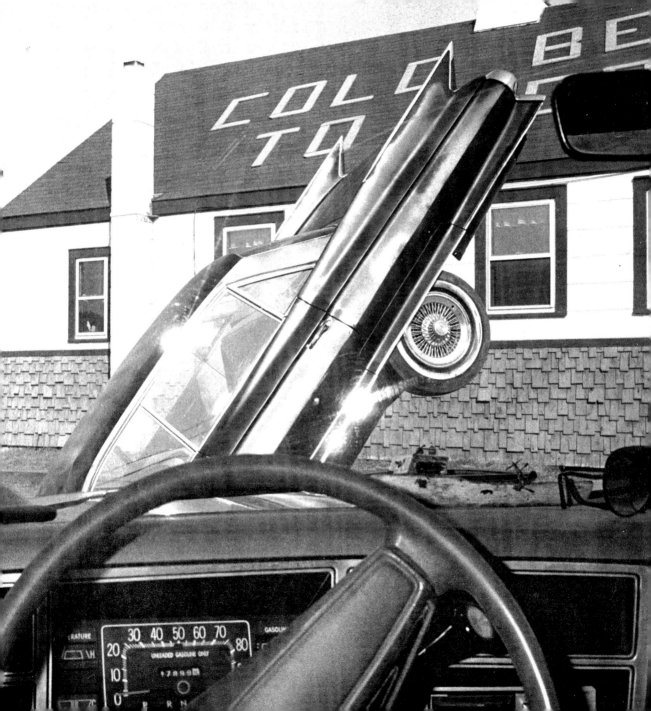

A week later Katherine is back from the Hamptons and wants to meet me for lunch in Chinatown. I don't have much to report and I don't like Chinese food, but I agree. She tells me about a lead, saying we should go to an art show nearby. Guess that's why she invited me.

On the way to the Featherstone Gallery, we pass a crowd gathered around a black limousine. I see the half-eaten body of a Wall Street bigwig on the backseat. We stand there in the sweltering heat, too amazed to be upset.

It's a chichi Soho gallery: shiny wooden floor and a pretty girl at the desk up front. The show is called New Criminals. One piece is just a puddle of blood on the floor. Another is a pickpocket who steals from the gallery-goers. The star of this gig made a video of himself murdering his father. This kind of stuff makes me mad. Some of these clowns even get money from the government to make this junk.

Katherine takes me to a back room, where I find a life-sized mechanical replica of myself. I understand that they are on to me now, that they'll stop at nothing. But who are they and what are their ends? I pull out some fuses and cut the wires inside the dummy's head. I decide to go into hiding.

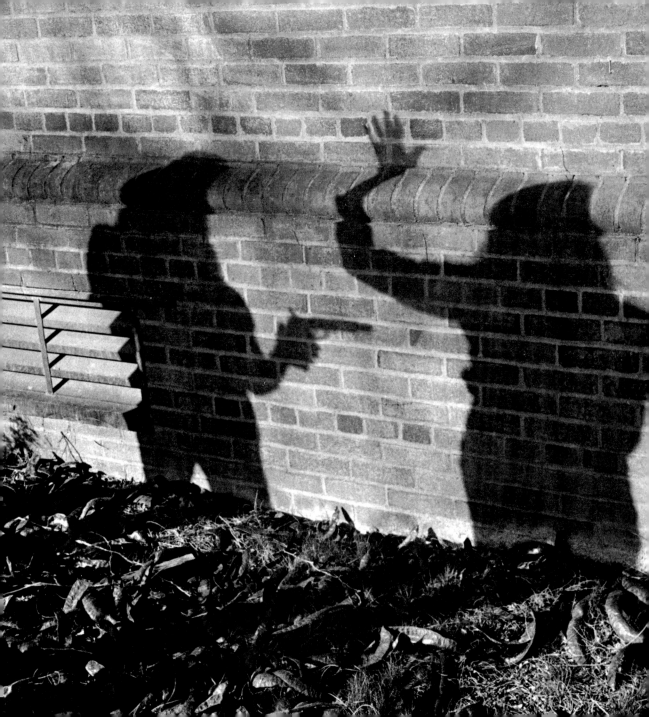

Worlds Apart

August has been real quiet except for all the headlines and fuss about the Eat the Rich Gang. These marginal types make me sick. I've been lying low near Jack's pool with a case of scotch and a deck of cards. Plenty of time to mull over the case. The clues are as slippery as a fistful of sardines. But I can see there's an imagery angle here. Image commerce is dirty business. Sure, there's a legit side–magazines, galleries, movies. But then there's the Sigma Parlors–dens of illusion mainly for the foolish rich. I'm not saying I've never been to a Sig. I've tried them a few times. Anyway, it's not so much the Parlors as the people who push the illusions and then fight for control. Could Rusty and the Doc have gotten in over their heads with this mob?

Early September there's a break in the case. I get a phone message at my office. The recording is full of long-distance static. It's that precise, clipped accent, like a nazi in a war film.

"You will find the map soon. Enjoy your trip."

As usual the Doc has me baffled. At least he's alive. But what about Rusty?

Waiting for that map to show up is really getting to me. Nothing much happens...I start thinking about that ad for the Jou-Jou, a swanky joint on the Gold Coast. Like I said, I don't go to the Parlors much, but I need a break. Anyway, it doesn't hurt anyone.

I go to the Palm Tree Lover's Retreat at the Jou-Jou. They strap me into the posh red chair. At first the palm trees look flat and the girls like cutouts. Then I turn up the 3-D dial. Suddenly it goes all strange.

The girls are larger than life, with gigantic knockers like mountains about to fall on top of me. I want to scream. The palm trees have green fangs and arms that reach out with nightmare fingers. The blue water of the lagoon is blood flowing from the wounded tropical islands. I scream, but all I hear is ukulele music whining like a sick child.

Next thing I know, I'm being jostled out into the street. I pass out. Everything is white.

As I come to, first the edges clear up, then the center. I'm leaning against a wall. I look down. I'm holding a piece of paper that's a white blur, like a cloud in my hand. Slowly, with great effort, I focus.

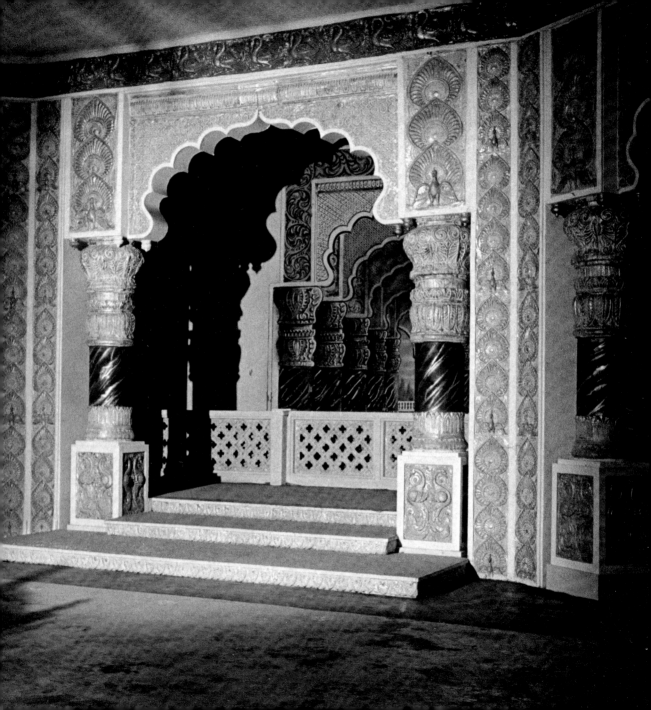

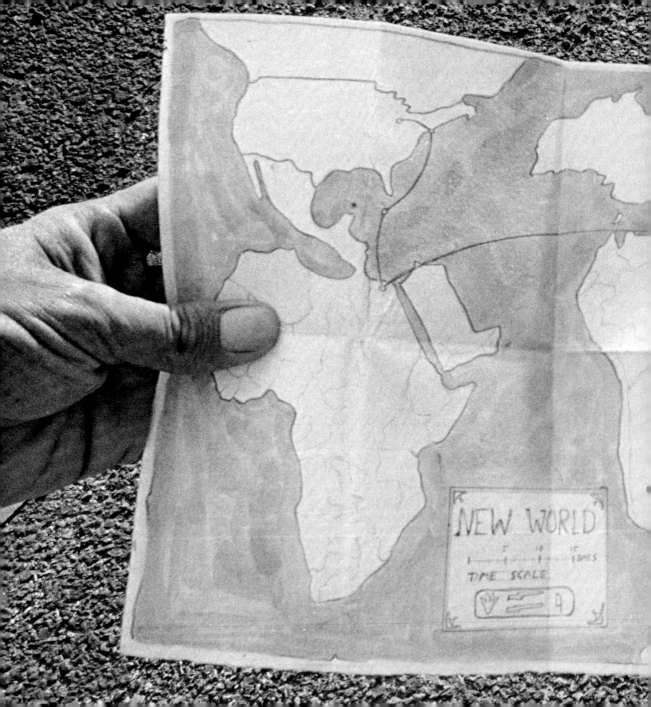

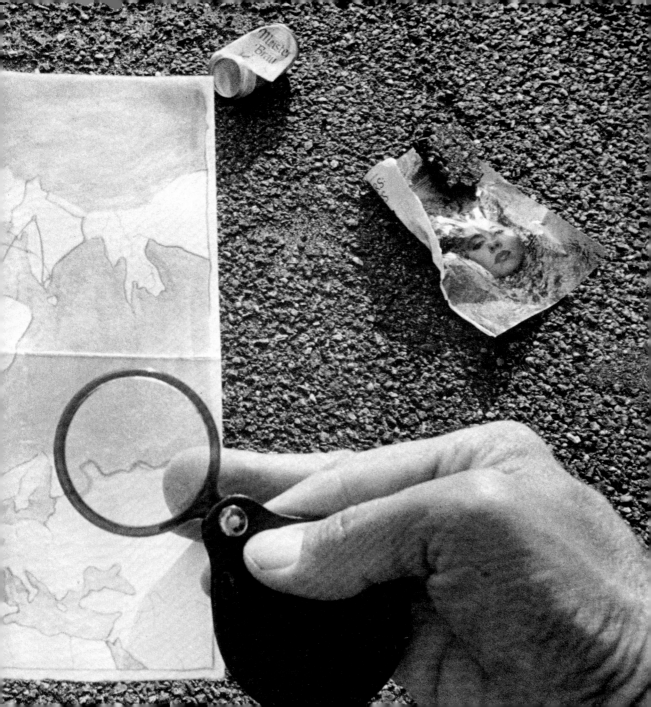

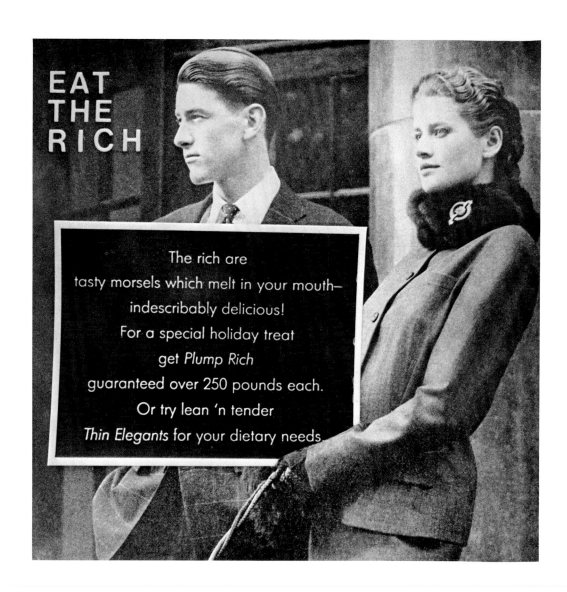

EAT
THE
RICH

The rich are
tasty morsels which melt in your mouth—
indescribably delicious!
For a special holiday treat
get *Plump Rich*
guaranteed over 250 pounds each.
Or try lean 'n tender
Thin Elegants for your dietary needs.

Eat the Rich

I stumble back to the office looking a mess. Janet stares at me like she's seen a ghost with galoshes. She looks cute that way. She makes a pack with some ice out of the little refrigerator I keep for my drinks. I casually mention the important new clue and the danger of detective work. I figure this is a good time to ask if she'd like to go out that evening. No dice.

Two days later, Katherine and I meet at a little Ethiopian café in New York. She's sitting by a window and looking good in that strange way. No hamburgers here so I have rice topped with a dark green goop. As we look over the map, I brush her hand slightly. She pulls back.

We talk about the Eat the Rich crime wave. The TV and papers are going wild over it. I tell her about seeing cops search people for forks and knives. I don't go into any details...leftover fingers and toes in the gutters. I'm glad it's only the really rich people. We're safe. Katherine says there's a tie-in with image scammers. She's doing a study of the ETR grafitti. Where she gets these ideas I don't know.

"Well, what do we do now, Rogue?"

"Let's get together tonight" is my first thought.

I don't think this is what she has in mind.

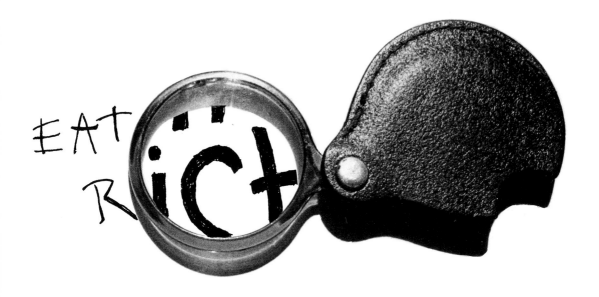

I'm busy planning the trip–getting passports, visas, tickets. My office forwards me some Want Ads from Jack. I see that Beeky, the Doctor's pet gull, is wanted, and there's a connection to ETR. I figure their M.O. is image defecation, and somehow they're tapping into the Sigma Parlor mob.

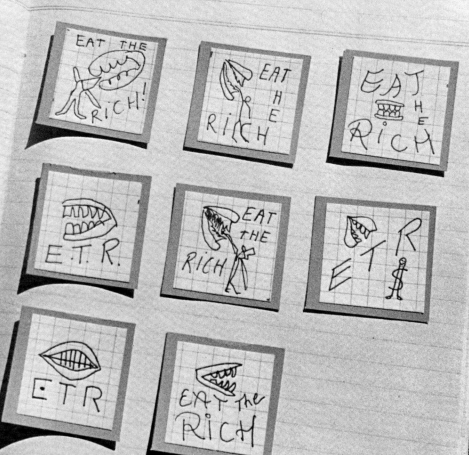

Agency Report

Subject wanted:

 Albert "The Rascal" Gibson
 b. 1982

Crime/Offense:
 Wanted for arms transport,
 intercultural treachery,
 flight from justice.

Description: A mean bird with a nasty
 habit of defacating in flight on
 the heads of pursuing agents.
 Evil glint in left eye.
 Addicted to seafood. and urchins
 in particular.

Comments: Dangerous (and dirty). Do not attempt to
 APPREHEND. CALL the Agency immediatly.

Agency Report

Subject wanted:
Roger "Beeky" Garibaldi
 b. 1980

Crime/Offense:
Wanted for international flight,
travelling without a permit,
fraud.

Description: A deceptively polite,
well-mannered bird. Do not trust
trust this behavior. Known to
seduce pet owners and bird
affectionados. Small tattoo on
left wing of with words "Eat the Rich".

Comments: If you sight "beeky", immediatly contact
the Agency.

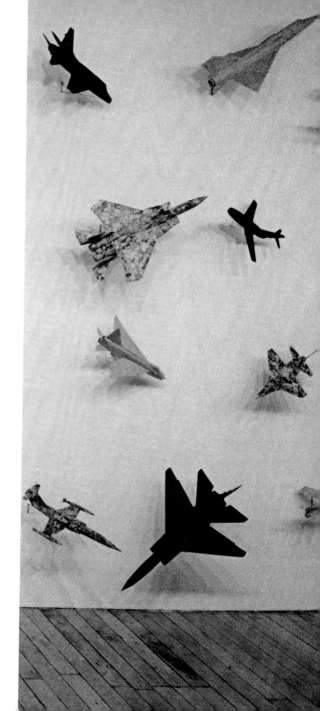

Before we leave, Katherine sends me to check out one of those arms stores run by the Agency. It's a dingy building by the river in Brooklyn. Groups of foreign men in strange get-up go there to buy toys for their armies back home. The salesmen, typical New Yorkers, are rude to the brown savages smelling of spices, sweat, and perfume. If the customers spend a few million, the salesmen manage a handshake and a smile that looks more like a leer. I guess arms are good for business. But what there is to investigate here, I don't know.

49

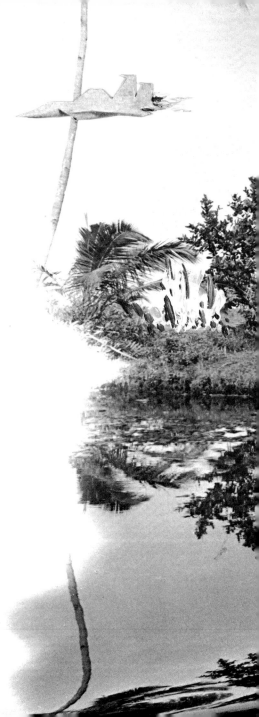

"When the men get home they have fun making some little border wars," Katherine explains later. "Newspapers glorify the skirmishes, and the fighters are happy to die." She pauses and adds, "come, it's time to travel."

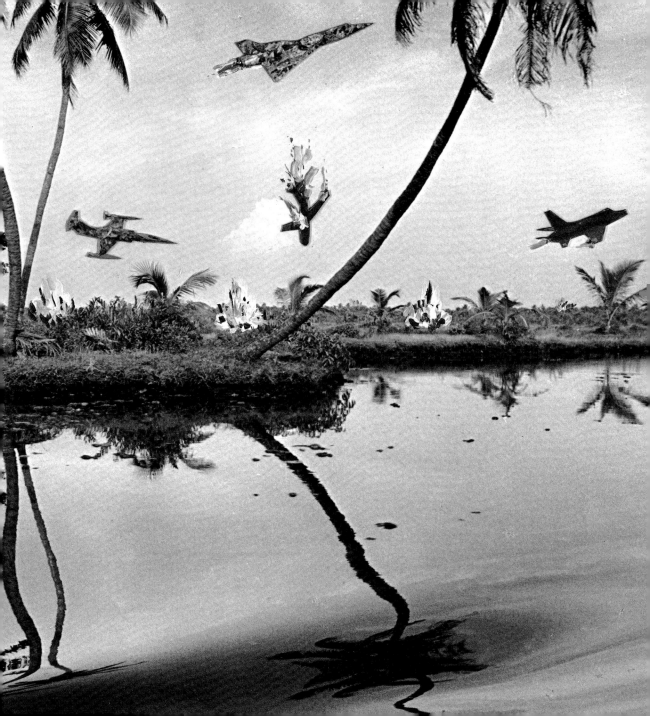

Pension Ægyptus

S ure, I've been on a lot of big birds, but never overseas. I figure San Gatitos will be like home except with people speaking in jargon. In the friendly skies, I relax with a little drink and a little think. Katherine's next to me in her sensible traveling suit. I look down at her legs–pretty nice. She's busy scribbling in her book. Too bad.

The airport is a mess. No wonder these people can't make GNP like us. Our beat-up taxi bumps down dusty avenues lined with wooden shacks. The Seaside Hotel looks beautiful from the outside, but inside it smells moldy. A thin man in a stained shirt takes me to my room. There's no hot water. At least the dark-skinned waitresses are beautiful–and for a small tip very friendly. Katherine's studying that map and a copy of the Slapstick Papyrus.

The next day I'm sitting on the balcony nursing my hangover. The chicks sunbathing by the pool make for some good sightseeing. Katherine comes up to me angry.

"If you're not too busy with your investigations, we did come here for a reason."

I don't know why she's so upset. She finally cools down and leads me to a crumbling, vine-covered hotel, Pension Ægyptus.

Turns out that Doctor Francisco's mother lives here. She's an old Italian woman in a rose-print dress. It's clear she worships her son. Funny she's not too surprised or upset to learn of his disappearance. She shows us her collection of T-shirts from the Institute of Obscure Knowledge. One has a comic egghead character saying "Happy Logarithm Day!" It looks like this is going nowhere fast until the old lady asks Katherine to translate some mysterious hieroglyphics on her hotel's sign.

"The big bird of Horus is flying over the sacred river. The man with the coat of images pursues the bird with his eye in the trance of the lotus."

I don't get it. Katherine explains that the man with the coat of images is me since I have this postcard shirt. Jack gave me this weird shirt that keeps changing pictures. Don't ask me how it's done. Something with a superchip maybe. Anyway, the point is our next stop is the Sacred Valley in Egypt.

Cairo

Egypt is a bad place—dusty, noisy, and full of pushy people in robes. The writing here looks like bits of spaghetti. All the old monuments are covered with those hieroglyphics, so nothing means much to me. To boot, the Arabs don't believe in booze, so drinks are expensive and bad.

Luxor

Our guide Mahmoud tells us that the place is crawling with rich tourists escaping ETR back home. I guess it hasn't spread here, but these vendors sure have hungry looks—kind of like dark animals.

"You buy alabaster now."

"Change money, good rate."

They're all out to make a buck. Mahmoud is greedy and smokes too many cigarettes. He gets this look like he knows something important that he just might tell us for the right price. He pretends to bribe people for information. Then he comes crying to me for money to cover expenses. I guess he's smart. Maybe I'd do the same things if I were in his turban.

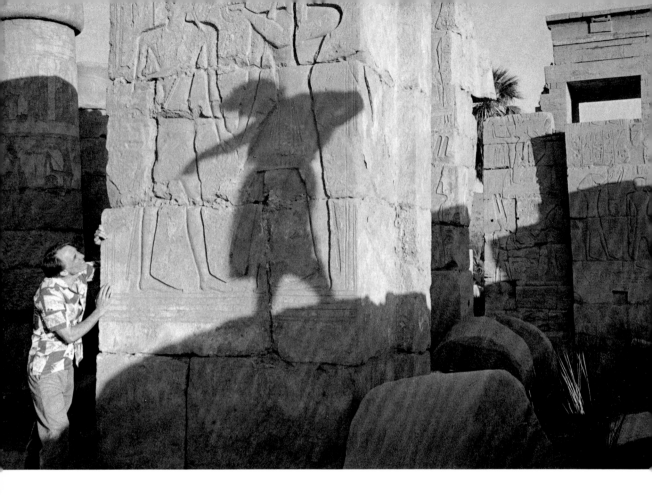

I tell Katherine that I don't see how these people can stay clean living in mud houses. How can they walk around in those long robes without tripping? She tells me I'm stupid. I like it when she gets a little mad. There she is in her sensible dress with that red hair gone berserk in the desert sun, looking sort of cute. But she's got a long ways to go to be a real woman.

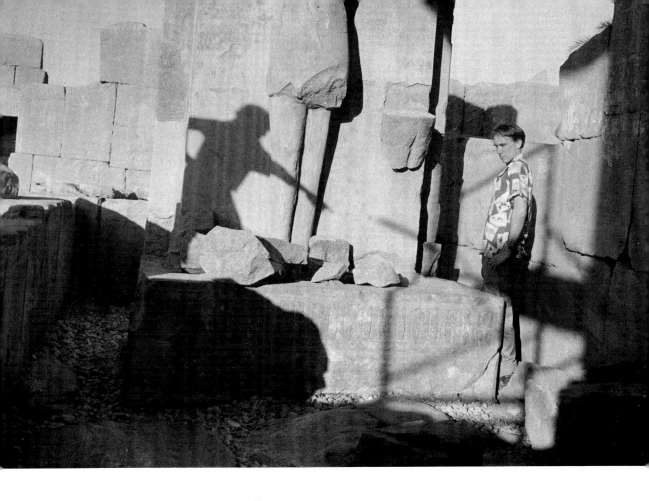

We do some serious investigating at the ruins. Katherine has a knack for seeing things. Near the Temple of the Large Bird we find another little white gun and some interesting papers. Looks like a plant to me. Katherine studies the map and papers. She concludes that we must find Professor Sundaram in India.

FAMOUS EXPERT ASTRO PALMIST

REMARKABLE ACCURATE PREDICTION
GREAT NAME IN ASTRO PALMISTRY SCIENCE
Prof: SUNDARAM.

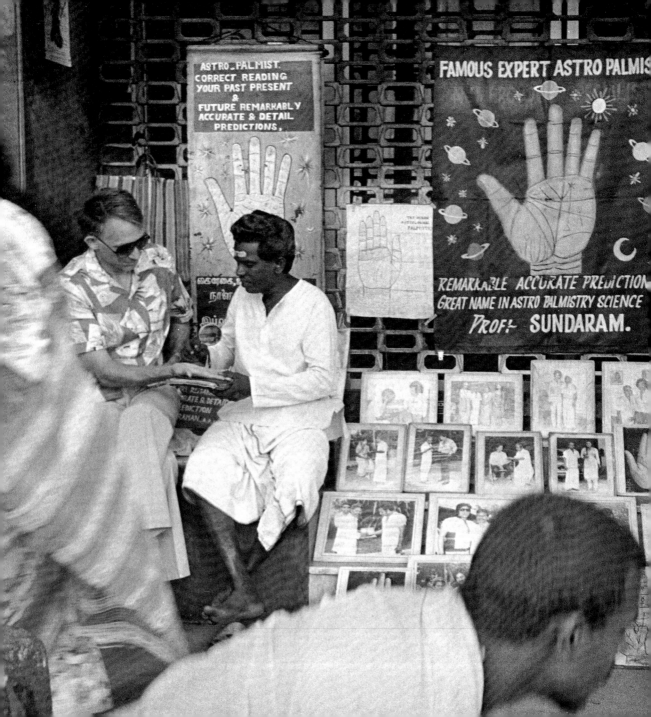

A Postcard Message

India. I'd heard about this country on the radio and TV. It's really crowded, but at least people speak English—well, a sort of English. The men are scrawny and kind of bow when they talk to you. I don't see how these skin-and-bones people can carry such heavy loads.

We find the Professor on Mahatma Gandhi Road. Katherine stays hidden, and I go up like I'm a regular Joe who wants his fortune read. He does a lot of poking, folding of fingers, and work with the magnifying glass.

"You will die and be reborn. Your mind will be made whole. I see here a man in a dark coat who tells jokes like a child...very old jokes. You are not laughing. You will learn about power and humility. Then you will be ready for a woman with almond eyes and rusty hair. Go South to learn."

A bunch of malarkey. But of course Katherine finds it all interesting. We book a night flight to Madras.

Going undercover is tough work, but sometimes you have to do it. The main thing is to blend in. As Jack used to say, "Look like the pavement."

I'm pretty sick of these dirty streets full of ragged people with bad teeth and no shoes. Looking for clues in a place like this is no picnic. This is no California TV detective show.

But this beach resort for foreigners is the best thing so far. Katherine hates it, but I think the chicks are cute and some go topless—which could boost anyplace. Investigating here isn't bad!

Tourists sit around these cafés eating huge meals with gigantic desserts and tall fruit drinks. They eat and drink and do drugs. There's even a crude little Sigma Parlor in the village.

I'm starting to see and hear some things that might be important.

"I just want to be alone on the beach. But these damn natives keep bothering me. They stare and ask silly questions."

"That's because people here are more real than in the West. They are warm, and human values are still important."

"Yeah? When we were in a car accident those people you're talking about came out of the jungle. They took everything. It was eerie how they looked at us pinned under the wreck. We were glad they didn't eat us."

"Let me tell you, every Asian is out to make a rupee. He'll be nice and courteous, but you'll pay. The Asian is a rapacious schemer."

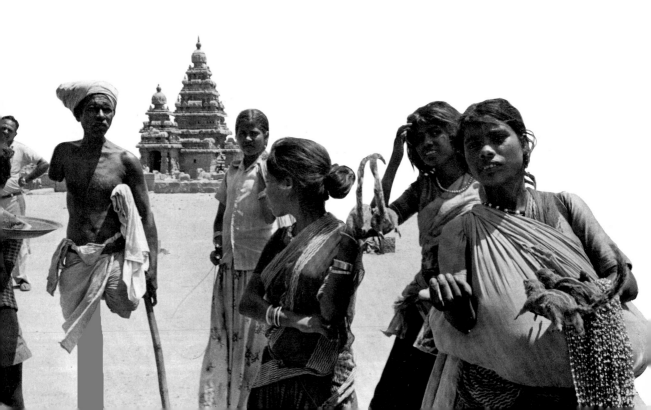

"No, no, the schemers are the arms dealers. They stay at the best hotels gratis. Their goverment escorts go to the village to get them women to enjoy. And the natives love them because they tip so well."

"I don't know about politics. I think the people are beautiful. I mean their bodies, the way they move, the flowing saris...they love flowers."

"Oh yeah? You like those cute kids swarming around you? Baksheesh! School pen! American coin! I call them professional kids."

"The only way to keep it all under control it to get in good with the ruling class. Send them to Harvard. Teach them manners. They'll do the rest for you."

"Hey, you guys, let's stop all this heavy talk. I got some good ganja, and god it's a nice day!"

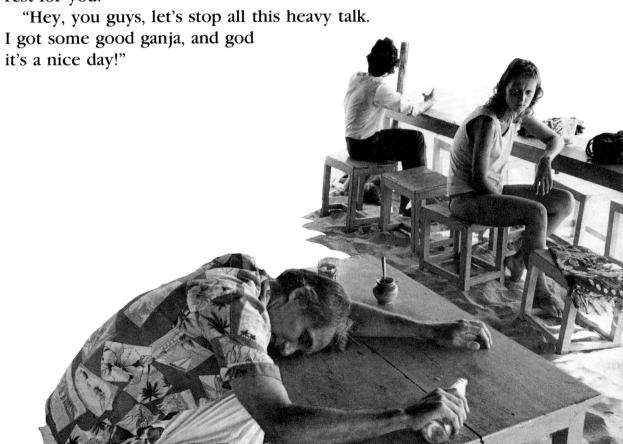

They tell me I got drunk and went swimming. All I remember is waking up on the sand and hearing two Indians talking.

"These whites are soft and pink. They are getting sick easily and never doing hard work. Look, their hands and feet are soft. I do not know where is their native place or what they are doing here. Do they work in their own country, or are they just having a lot of dark servants? I think they are not healthy."

"I do not think that they use good hygiene. They mix the left and the right hand. Then they are having so many stomach problem."

I pass out again. When I wake up later Katherine is looking at me, I swear, with tenderness. She says we can leave now.

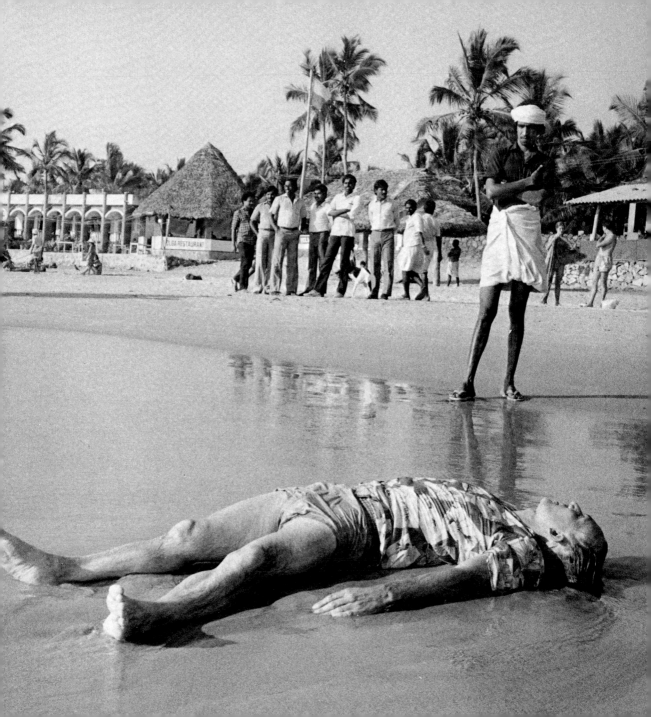

Madras

I'm out on the street investigating again. A gust of wind blows dust in my eyes. I hear birds screeching. A black swarm flies overhead, casting a big shadow. There's a flickering on my shirt, like when it changes pictures. I look down. There's a postcard I've never seen before.

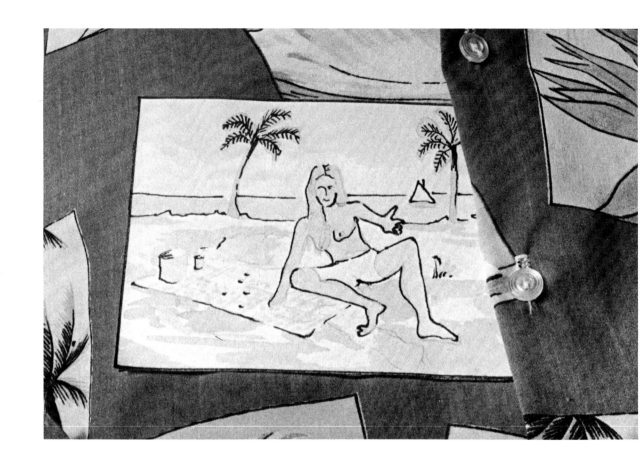

My first thought is *Katherine is not going to like this*. I guess she's a prude. But anyway, then this really amazing thing happens.

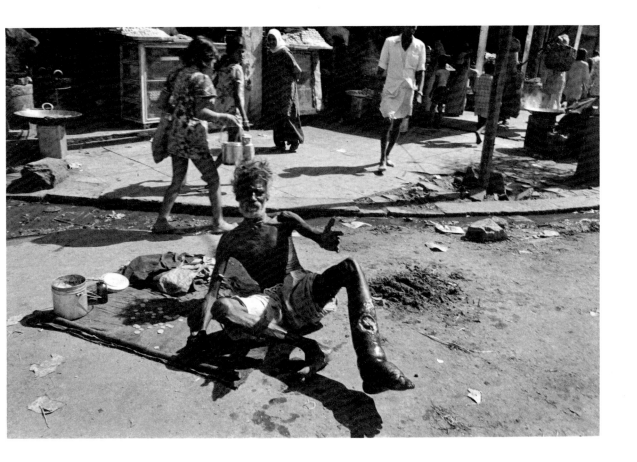

I see almost the same shape as the picture on my shirt–except it's a beggar lying in the street. This does something really weird to me. It's like shock therapy. My mind bounces from the postcard to the reality, back and forth.

I know something's up for sure. My shirt has never pulled a number like that before. It's like someone is controlling it, or trying to send me a message.

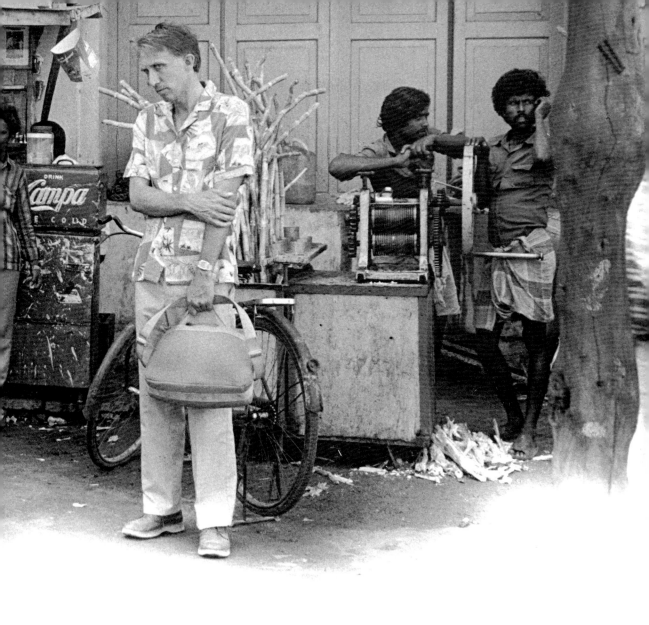

I am shaken. I am walking the streets alone with suspects everywhere.

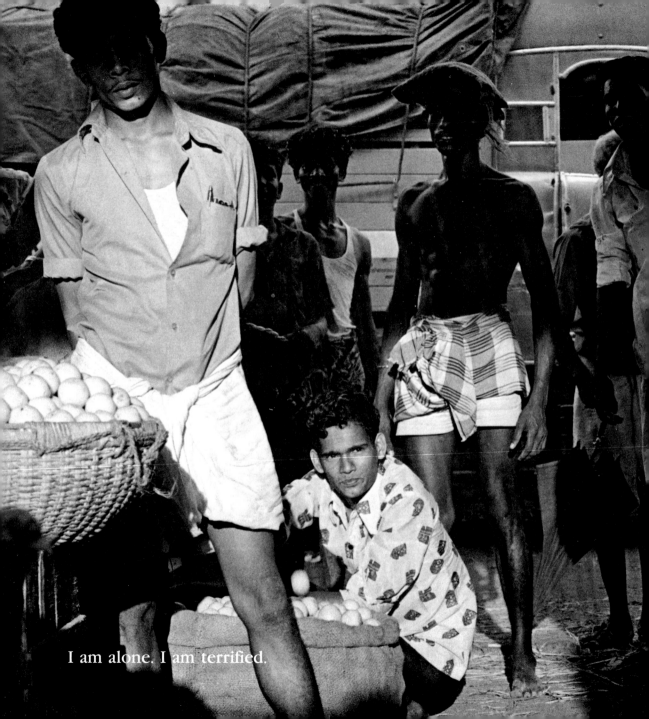

I am alone. I am terrified.

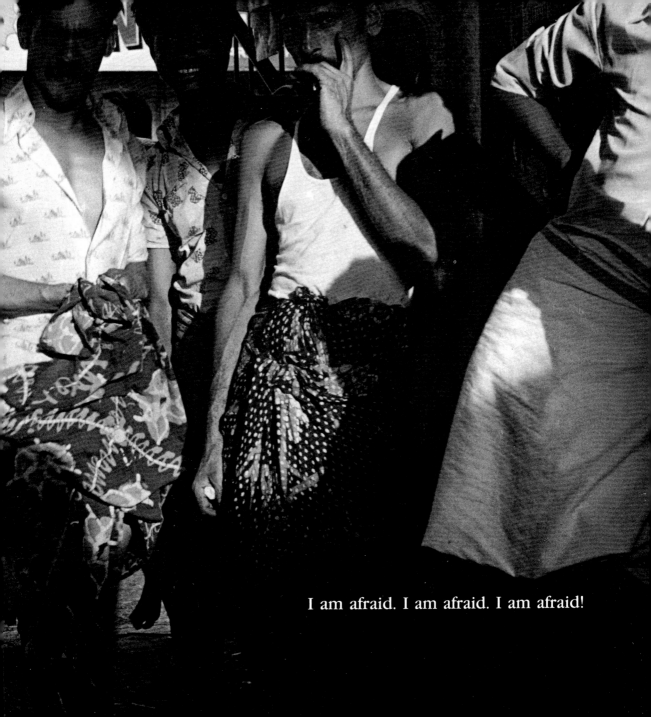

I am afraid. I am afraid. I am afraid!

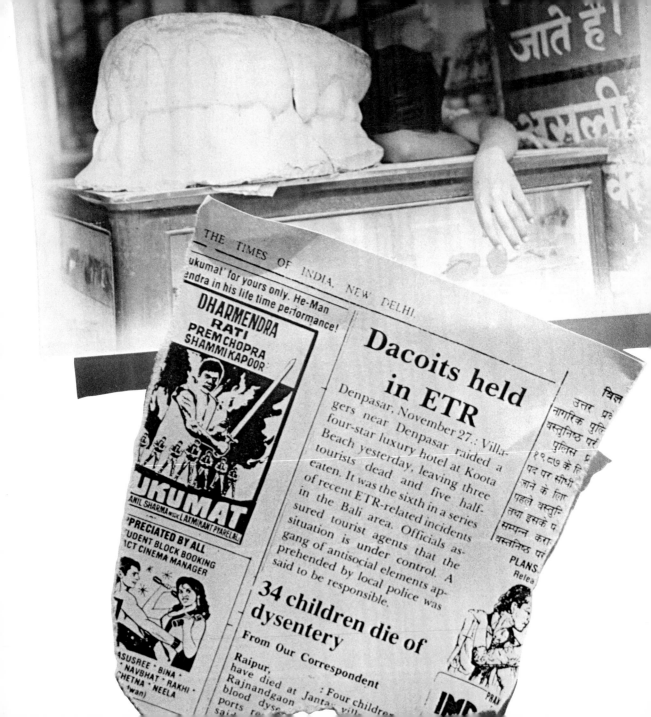

The Three Stones

E TR is spreading rapidly. We're warned to stay in the main streets and not to go out at night. Tourist wars have broken out in Indonesia, Brazil, and Thailand. I'm glad it isn't happening here yet, although the large plaster teeth are all over the bazaar.

Katherine is being very nice to me. I'd say she's getting sweet on me, but I don't want to push it. She's looking sexier than ever.

Then there's this whole crazy case. I don't know what I'm investigating. I go out and wander aimlessly. At night I tell Katherine all about it. She seems pleased no matter what I say.

<div align="right">Ajmer</div>

We walk into a small restaurant. There is an engraving of the Hall of Beauty on the wall. Katherine is very excited and discusses something with the owner.

"Yes," he says. "First, by plane to Ancient City. Then three days by walk in the land of the stone people. Rajan can take you."

We fly in a four-seater to Ancient City, which is cut off from the outside by a desert and a mountain range. Katherine tells me that the people live in ruins—carrying on the traditions of an ancient culture. The pilot mentions that a mysterious man in a dark coat passed through a few days ago.

I show him a picture of the Doc.

"Ave Maria!" he cries out. "The sahib gringo he have black hat on kaput and grande coat. He some sympatico but laughing like niño. Ya, ya, me hope you find him. In sh'Allah. Auf wiedersehen, monsieur."

At Ancient City Rajan, who has been very quiet till now, acts upset.

"That not good man!" he burst out after the pilot leaves us. "I was being more young as now. I be milking the cow for my uncle in Jadipuram. That pilot he come by with a Kodak. He take a snap. No ask, just take. He say to me he work for that Agency. The picture it be used for a test. Do you know this test?"

Sure I do. I flunked it. Jack didn't, and that's why he's in the Agency and I'm out.

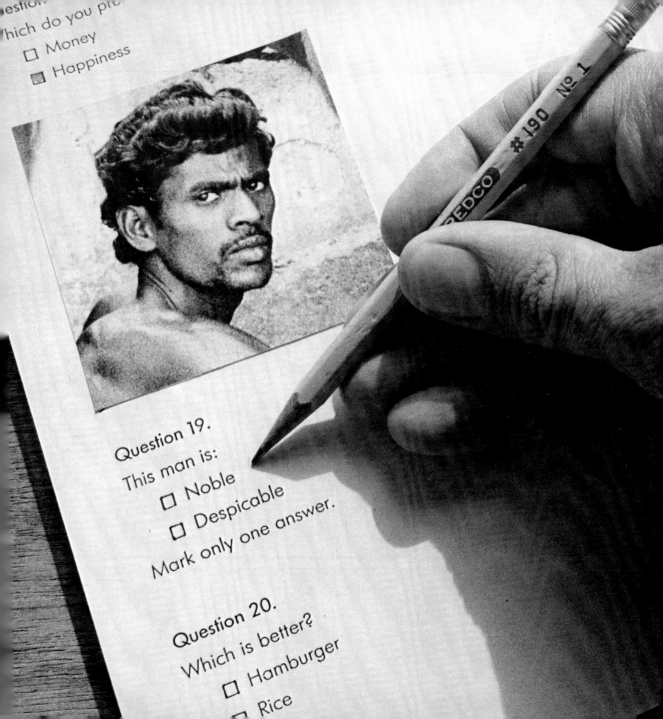

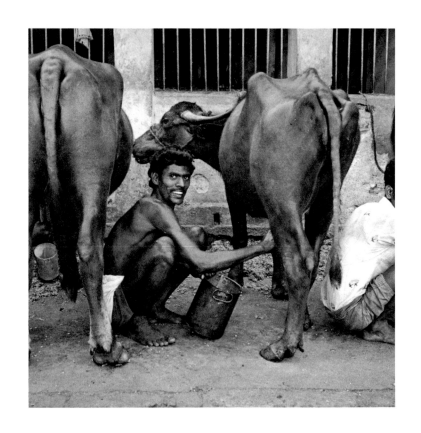

Every story

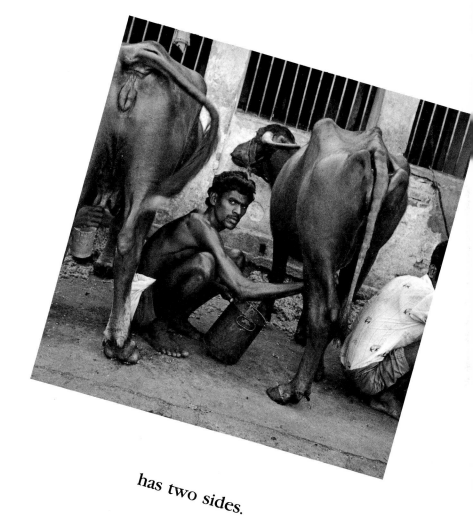

has two sides.

The test is called IRP, that stands for Image Recognition Profile. It's supposed to tell if you can hack work at the Agency. There weren't any long, hard questions. They were just fishing for a lot of opinions, and I guess mine weren't good enough. Anyway, I know agents can be pretty blind. A thing can be right before their eyes and they won't see it—like birds in the sky.

We agree to leave early the next day since the sun gets hot at noon.

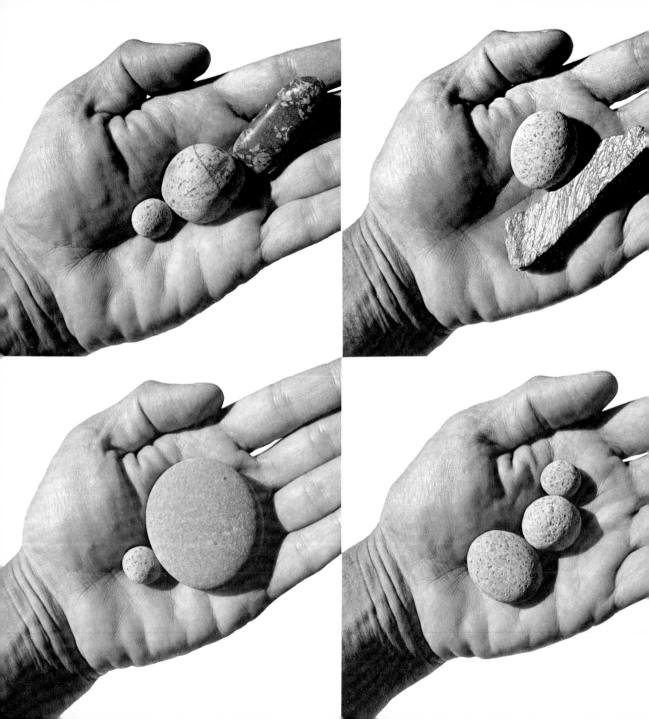

We hike along a dusty trail to a secluded valley. Rajan explains that the people here communicate by the use of stones, not sounds and words as we do. We see them huddled in silent groups, each person with a pouch of rocks on a belt. Rajan calls these pouches "vocal cords." Katherine is fascinated and decides to spend some time here.

I go into the mud hut where she is making notes and photographs. It's hot in there. Her hair is damp, and her cotton dress clings gently to her hips. Pretty sexy! She smiles.

Before we leave this part of the valley, she gives me three little stones. I remember Rusty had given her three stones the last time he saw her. I think I understand.

We finally get to the Hall of Beauty. Our water is running low, but our spirits are high. Hieroglyphics on an ancient Indian temple? I'm no scholar, but I can smell a fish. Katherine carefully studies and records the symbols. Many are from the Slapstick Papyrus. Could Ramses IV have ruled here a long, long time ago with his jokes? Katherine thinks not. She says we are near the end of our trip. I don't see how.

The next day a savage man comes out of a hole in the ruins. He has a long talk with Katherine. They're using that stone language. After writing things in her book, she comes up to me excited.

"I know where Rusty is...and maybe Doctor Francisco too."

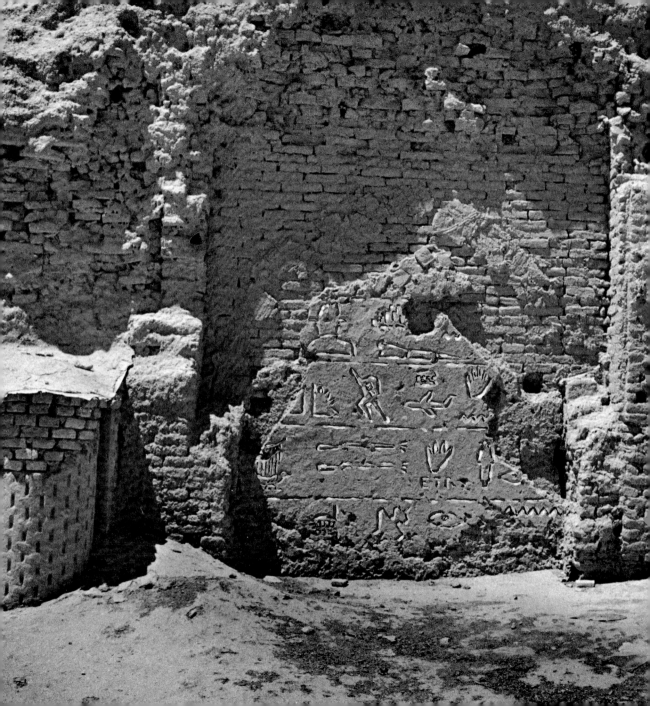

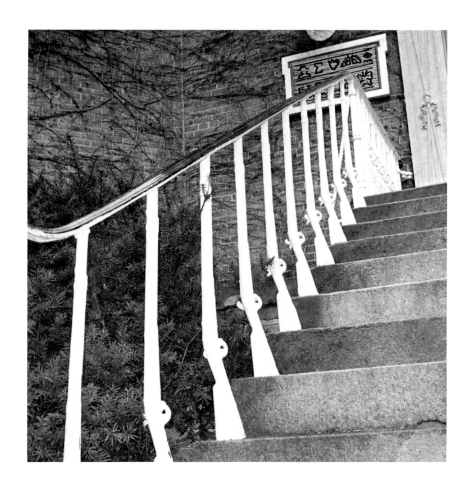

The Butterfly Collection

I've heard Brazil's beaches are beautiful, but we go straight from the airport to the diplomatic section São Augustino. It is siesta time, and the guard at the gate is reluctant to let us enter. But when Katherine shows him a few stones in her palm, he waves us on. Sometimes I wonder. If she knows so much, why does she pay me all that dough to follow her around? A shiver goes down my spine when I see the neat row of white guns supporting the railing. Katherine takes my hand and leads me up the steps. I hear the shrill cackle of birds circling overhead.

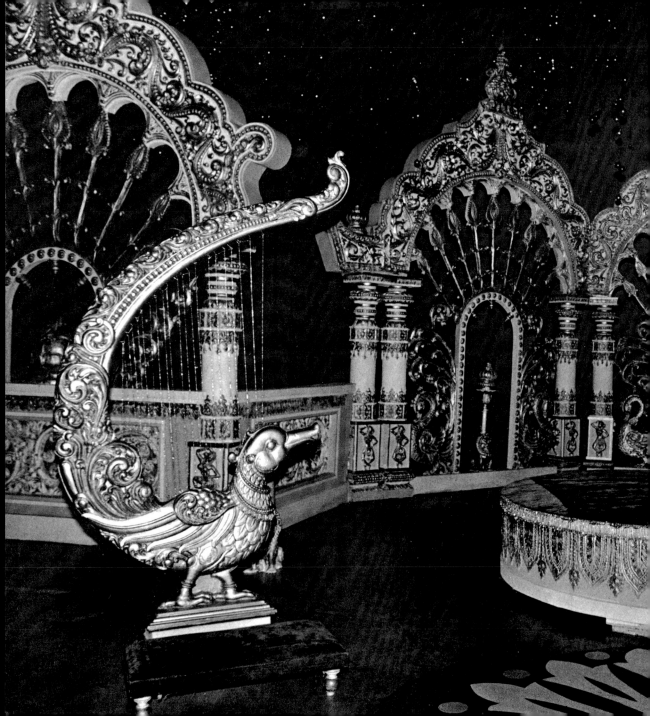

The lobby looks like a Sigma Parlor. Katherine immediately sees the harp-bird from the Slapstick Papyrus. I'm feeling weird. There's no one in the room.

"Why have you come?" a voice booms out from a speaker.

"We believe that you may know the location of Rusty Savage, the Egyptologist who disappeared from the Hall of Beauty in New York," Katherine says.

"Indeed, I do. If you care, or dare, enter through the second door by the golden swan."

We step into a provincial Amazonian museum. The voice asks us to sign the guest book. As Katherine pretends to write her name, she scribbles a secret message to me.

"Careful, Dr. F. is near."

Pretending to sign, I write: "I think I'm in love."

She smiles and takes my hand. I don't know if we are in a real museum or living a Sigma illusion. We hear footsteps echoing down the hall.

"Would you like to see my butterfly collection?" says Doctor Francisco greeting us.

The Doc looks smaller than I remember. He leads us into a room filled with old scientific equipment that reminds me of Rusty's place. The Doctor looks at me solemnly.

"Rogue, your brother was a hero—a modest but brilliant man."

"What do you mean 'was' Doc?"

He and Katherine are standing side by side. I realize that they are together on this thing.

"Time was short," she says. "We did what we could. After losing Rusty, we turned to you."

"Will someone please tell me what's going on here?"

"The Agency has been using ETR and the Sigma Parlor mob to control the world," the Doctor explains. "Rusty, Katherine, and I made the Institute of Obscure Knowledge our base. As I always say, 'fight imagery with imagery.'"

He giggles in that funny way. Katherine looks at him with admiration. What she sees in him I don't know.

"So what happened to Rusty?"

"He was brave," Katherine says gently. "He volunteered to enter the Hall of Beauty by himself to bring back imagery that could be used against the Agency and save the world."

"So what happened?"

"We think he got stuck in a hieroglyphics transformer."

"A what?"

"That's a device that shreds reality and transforms it into symbols."

"So he's a symbol now?"

"Rogue, you're not as stupid as you seem," the Doc says.

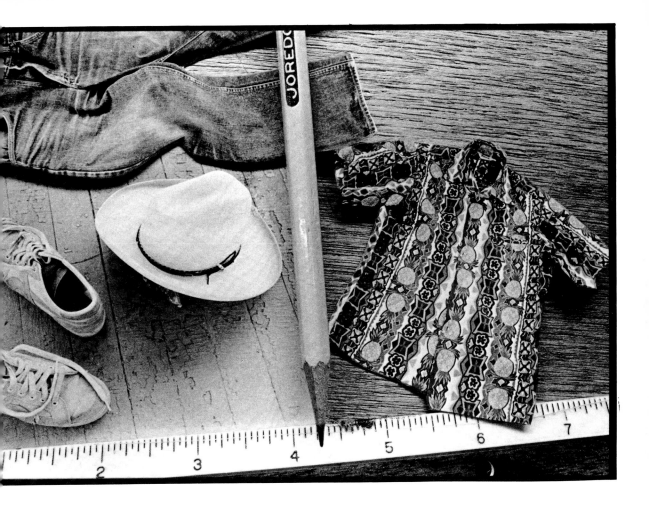

They show me the shrunken clothes—all that's left of my twin brother. I'm shaken up, but I also feel a little proud since they seem to admire him so much.

"So where do I fit into all this?"

They lead me to the next room, the butterfly collection. I look down. I see myself and Rusty as butterflies. Then suddenly *I* am lying down. I feel the glass pressing against my body. It's hard to breathe. I can see the Doctor and Katherine as two huge heads looking down at me. I am out of breath. I want to scream, but the glass is over my mouth.

Then just as quickly I am back in the room. Katherine holds me. I am trembling. I feel like crying.

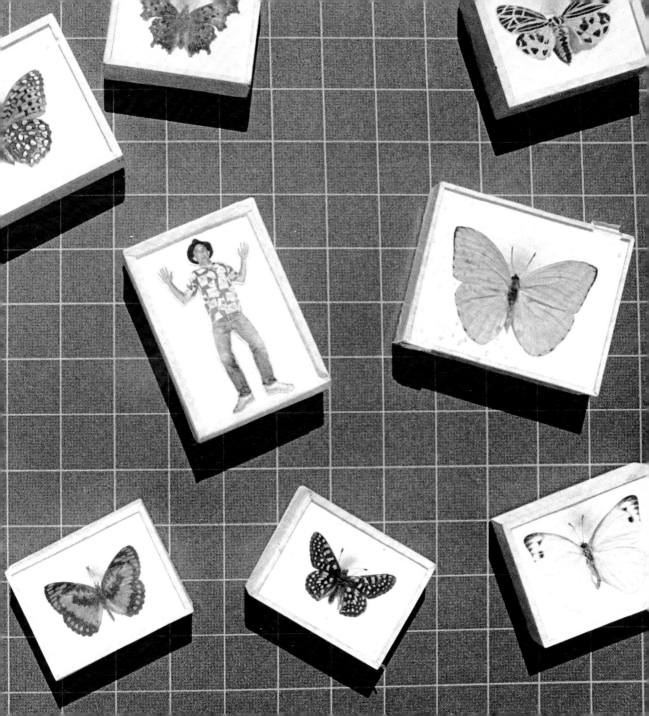

Textures

Paper

Wood

Flesh

Third World

Inside the Image Factory

T he Doc feels my pulse.

"You're a brave man, Rogue. You see, the Slapstick Papyrus is our only hope–that and the birds. Slapstick is no joke. If today's rulers knew how to use jokes, there would be no ETR, no Agency, no Sigma Parlor mob. Just laughter. Ramses IV understood that."

"Look Doc...and you too Katherine. I don't know what you're trying to pull here. I'm just a private eye from Chicago. I'm not out to change the world."

"Quite right. Let me explain. We have taken one man, as typical as possible. That's you. We have put you through a series of experiences that were all completely controlled. The Slapstick Papyrus was our guide."

"But how could you control everything?"

"An excellent question. Katherine went with you as your guide, and we created images around you. These images were manufactured here."

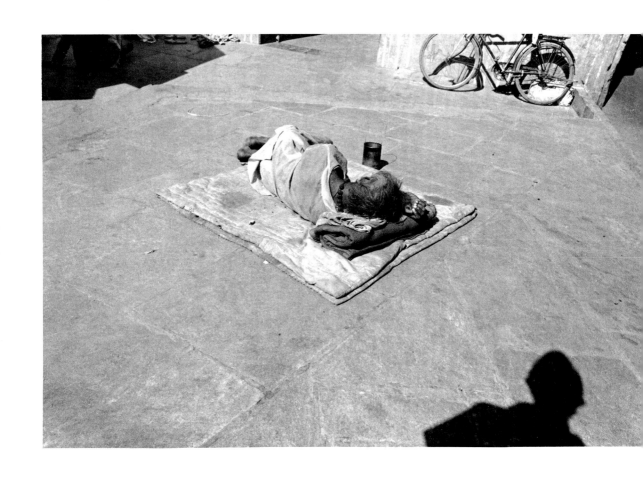

"In our Image Factory we can take a scene, say in India.

We re-create it using advanced image duplication procedures."

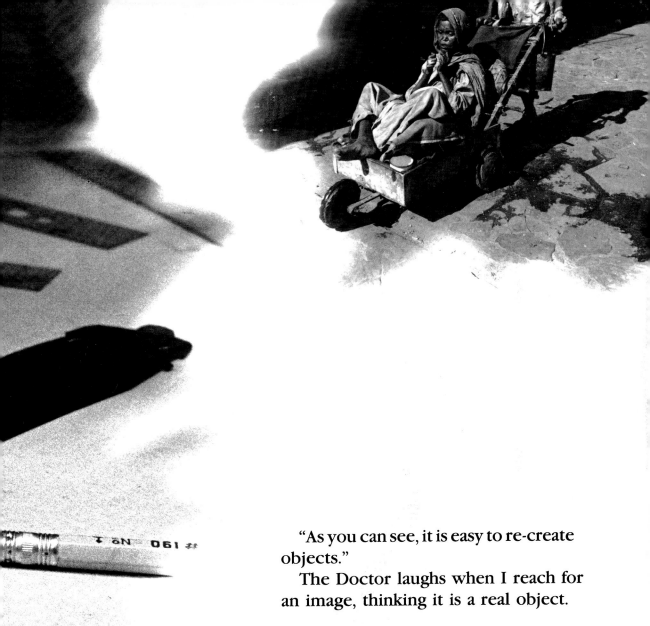

"As you can see, it is easy to re-create objects."

The Doctor laughs when I reach for an image, thinking it is a real object.

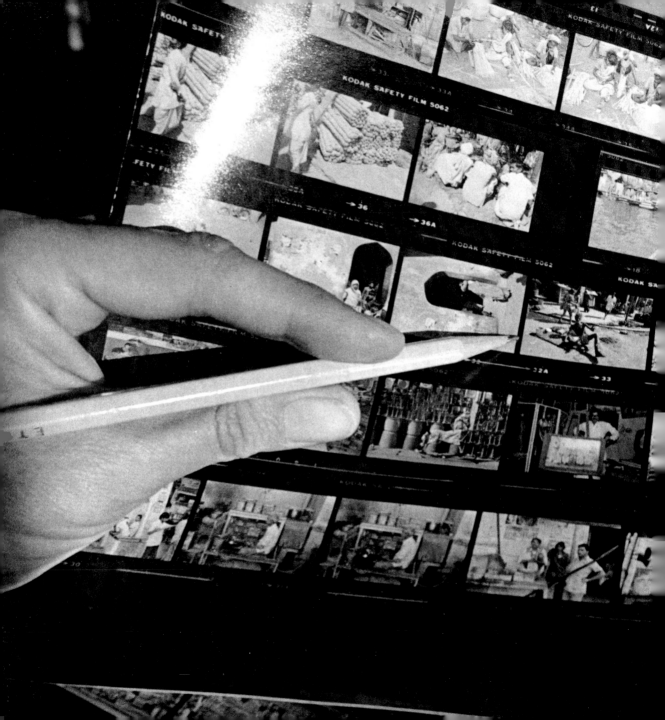

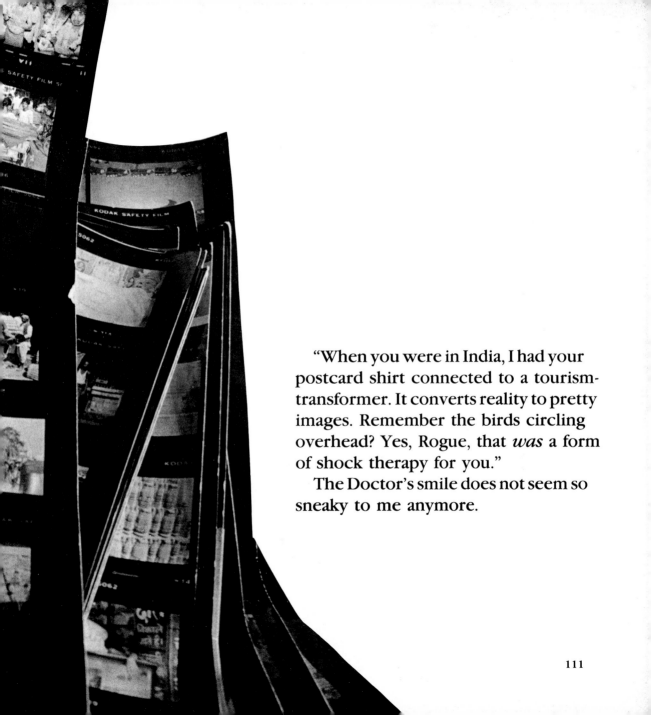

"When you were in India, I had your postcard shirt connected to a tourism-transformer. It converts reality to pretty images. Remember the birds circling overhead? Yes, Rogue, that *was* a form of shock therapy for you."

The Doctor's smile does not seem so sneaky to me anymore.

"Now let me teach you something. All power is based on separation. The rich are separated from the poor, the law-abiding from the criminal, the Chinese from the black, the men from the women, water from land, light from darkness. Separation creates *the other* and that leads to insensitivity, even cruelty. Misfortune is what happens to *the other*. You hear of ETR in Indonesia, and your first thought is 'I'm glad I'm not there.' Think of that, Rogue, as you sit at your image box examining a reality you cannot touch."

"But what about the birds, Doc?"

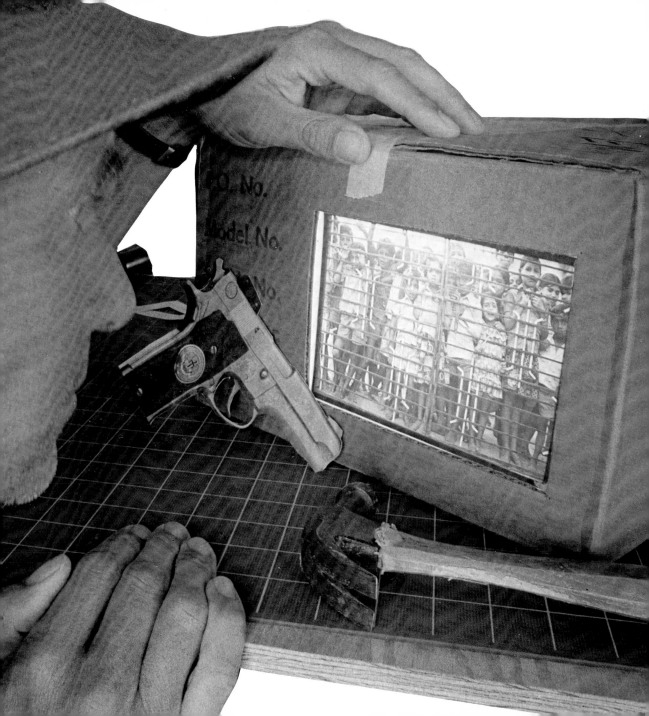

"The birds destroy separation. They bridge space freely. They laugh at political boundaries and structures. Ramses IV understood this. His are the greatest jokes eve told, and I have carefully materialized them. You, Rogue, have been privileged to have one after another of Ramses' jokes played on you."

I get it. The Doc is trying to
tell me that I am the butt of
jokes by some Pharaoh who
has been dead for 3000 years.
That takes all!

"Peel away the skin of a
Western private eye and
you'll find a Third World
man," the Doctor says as if
cracking a very funny joke.
"The Third World man lives
inside you."

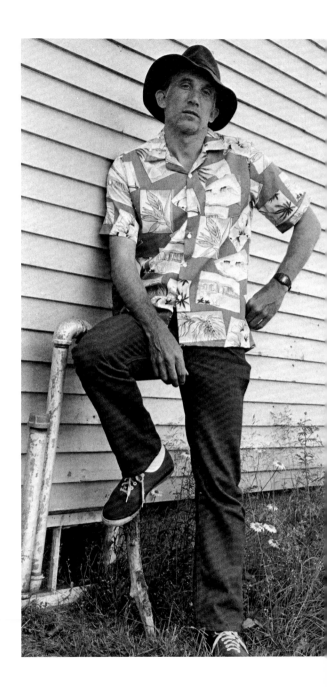

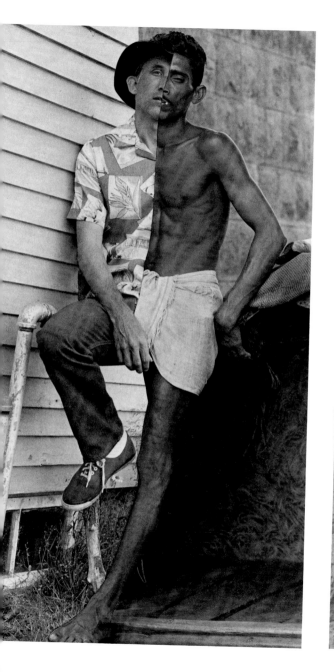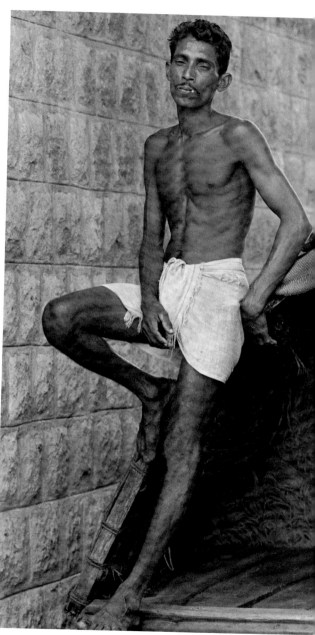

"Now, Rogue, I have prepared for you a really delightful joke."

But it is not delightful...I am an Indian beggar in the middle of New York City. I hear the cackle of birds and Doctor Francisco's laughter in the background. After what seems like a long time, he calls me.

"Rogue, you may come back now. The last joke of the Papyrus has been played."

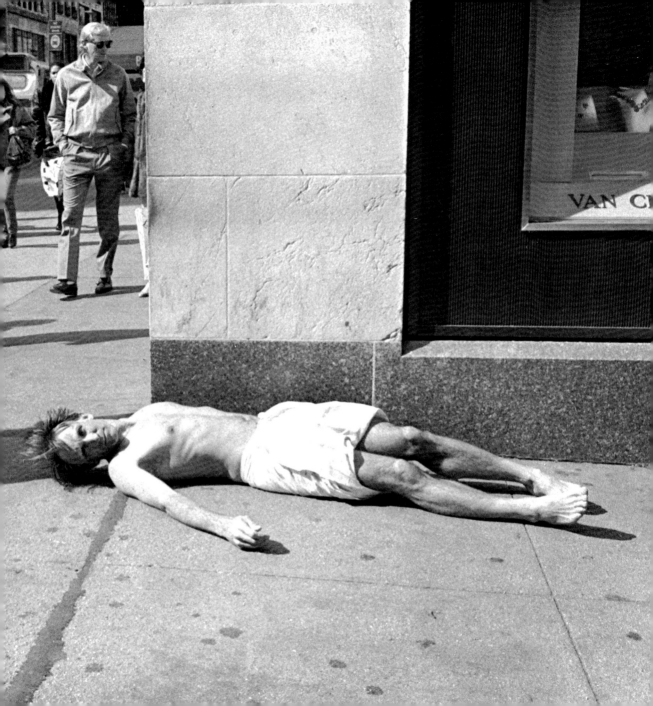

The Doctor's grin is wide and friendly. I don't really know why I'm smiling back. Katherine is smiling too. Then the Doctor bursts out laughing, and we all join in. We keep it up for hours. Our cheeks hurt from so much laughter.

"Do you want to confront the real mystery, the source of all images?" he asks giggling.

We burst out laughing again as if this is a great joke. I have my arm around Katherine, and the Doctor is standing behind us.

"I will show you the cave, the greatest joke of all time."

So this is why Katherine was always talking about that cave. I understand what the Doctor is doing with his army of birds and his web of obscure symbols to subvert the image controllers. I look down at my shirt—now covered with pineapples. I have found Rusty. I have become Rusty. I am able to read hieroglyphics, and I can laugh at the jokes of the Slapstick Papyrus. I can transcend time/space with the joke of hyper-relativity. I was a bird. I am an Egyptian. I may be a feather one day.

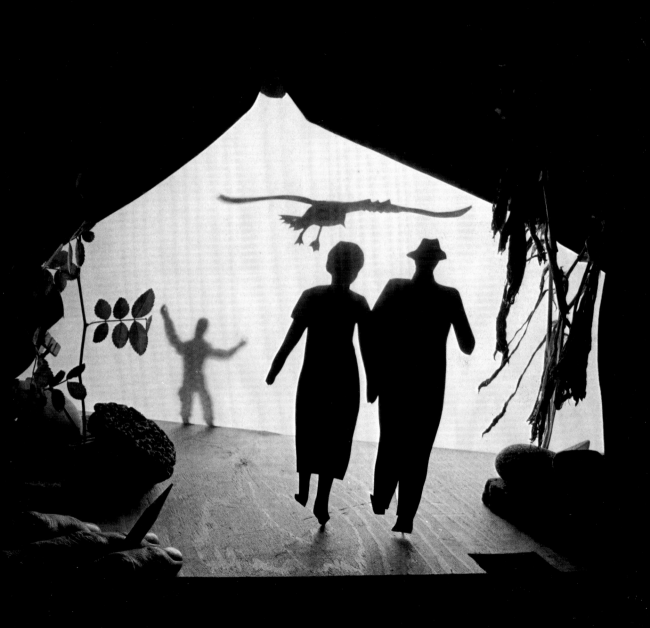

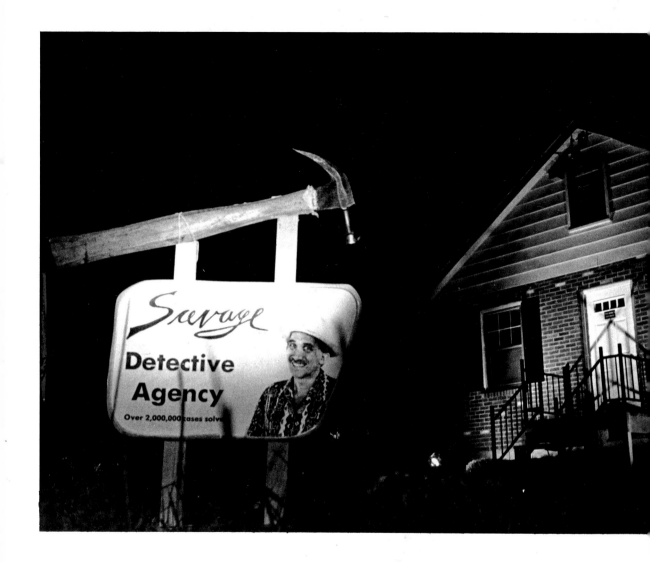

T hus ends *The Return of the Slapstick Papyrus*. As any schoolchild knows, the Eat the Rich Campaign came to an end, Sigma Parlors disappeared, and leaders now have a sense of humor. Doctor Francisco is an international hero, with statues at both the North and South Poles. Katherine married Rogue and they had twins. She finished her book, *Non-Verbal Languages of the World*. Rogue quit drinking and started a successful chain of detective agencies.

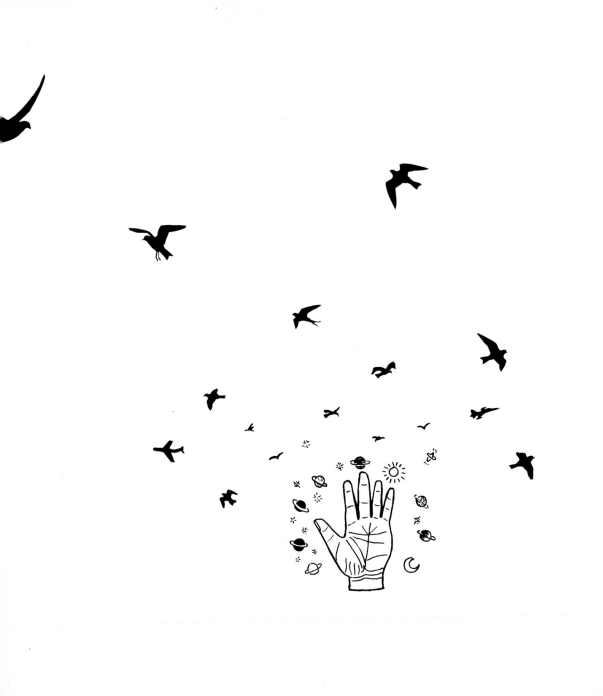